Markings

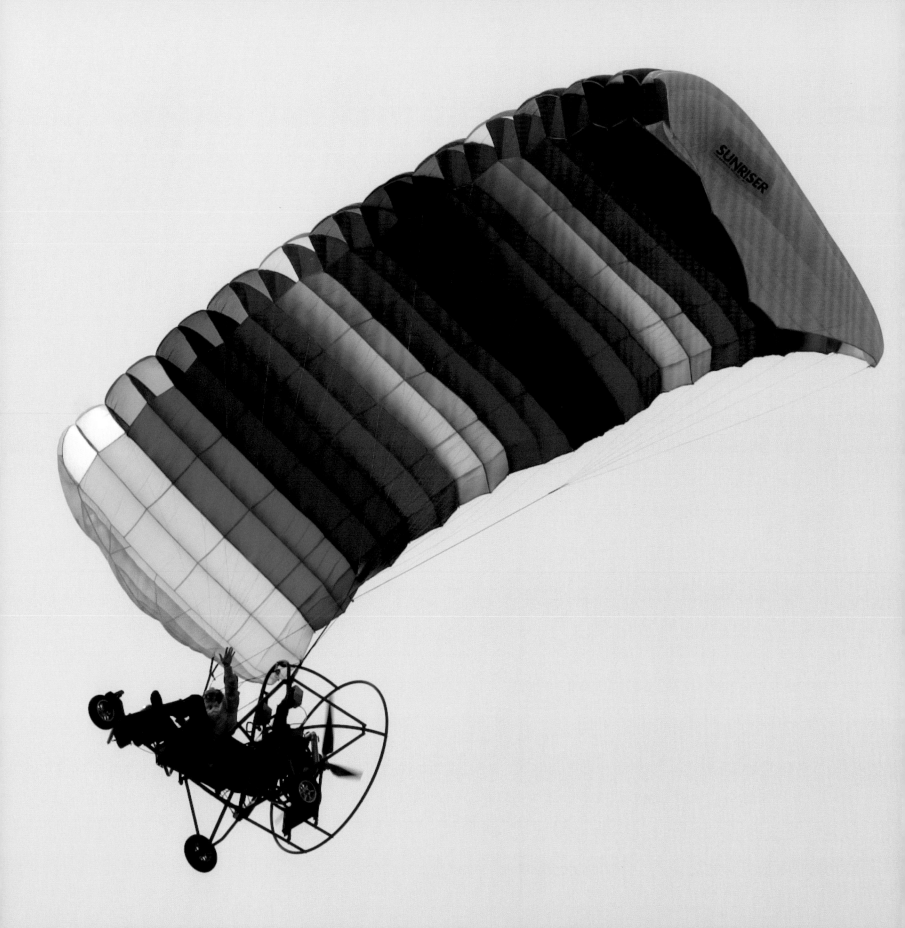

Washington, DC, and Berkeley

Markings

Photographs by Maxwell MacKenzie

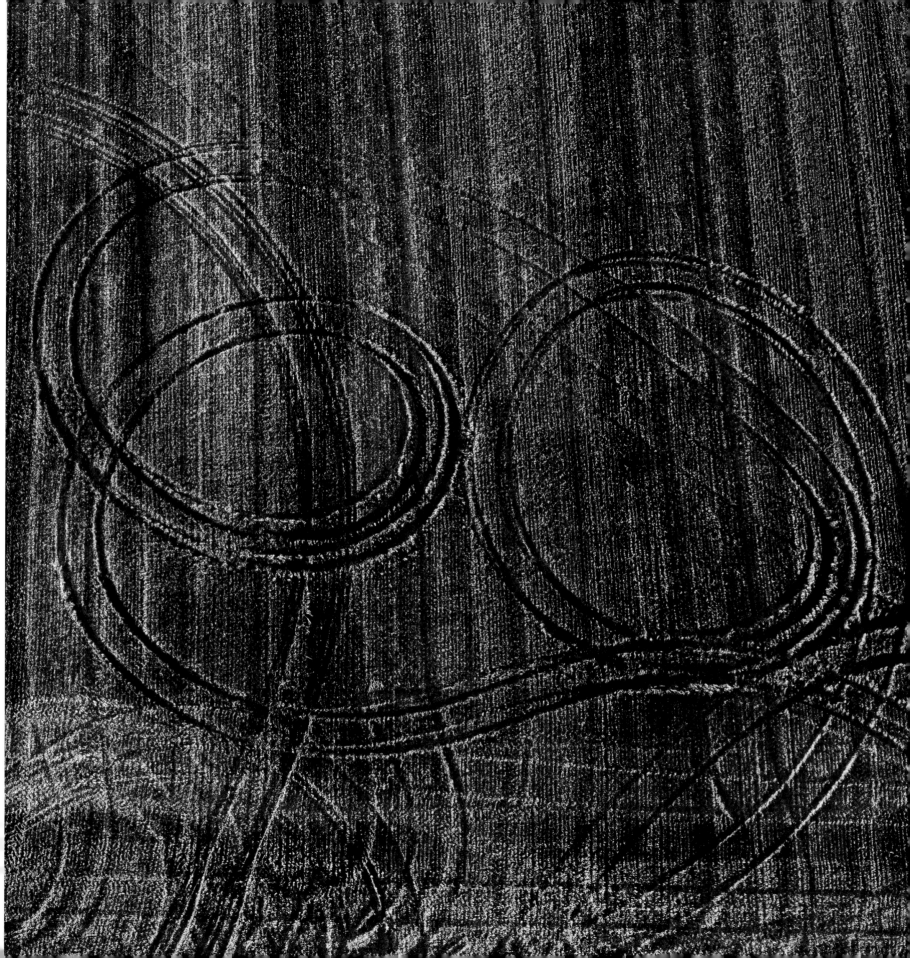

To see all there is to see with absolute clarity certainly seems a lofty, if not impossible, goal. But that was my exact thought when I first saw *Abandonings,* the pristine early photographs of Maxwell MacKenzie. To my mind, these long horizontal views of the rural landscape and vernacular architecture put the "pan" into panorama. They dance right up to the edge of nostalgia's abyss before rescuing themselves with lyrical formality and technical mastery that place these works in the forefront of what can reasonably be called contemporary art.

In the images collected here, the horizon line disappears over the familiar forests, fields, and townships of Otter Tail County, Minnesota. Long shadows and the imprint of the plow make for an elegant, if accidental, geometry that spreads over the ground below like a wide net.

If, in the words of Walker Evans, the photographer's greatest talent is to know where to stand, then MacKenzie can hardly be faulted for the death-defying positioning of a Nikon F5 camera with Ken-Lab gyrostabilizer on the flight deck of his ultralight powered parachute. These two contraptions are just what Leonardo da Vinci had in mind when he envisioned the mechanics of manned flight and camera obscura. I'd like to think that what MacKenzie has accomplished in *Markings* would have made old Leonardo proud.

It is a given in the art world that irony is an article of faith. When MacKenzie pairs the elevated language of poets from Plato to Billy Collins with his inspired documentation of terra firma turned to agriculture, he continues to court disaster. But this is a provocative and triumphant landing. When Carl Sandburg laments, as he does on page 40, that "those who saw the buffaloes are gone," he is wrong. There is much visual evidence to suggest that Maxwell MacKenzie still sees the buffaloes in all their metaphoric plentitude. And because he does so, we are marked, improved, and above it all.

William Dunlap
McLean, Virginia

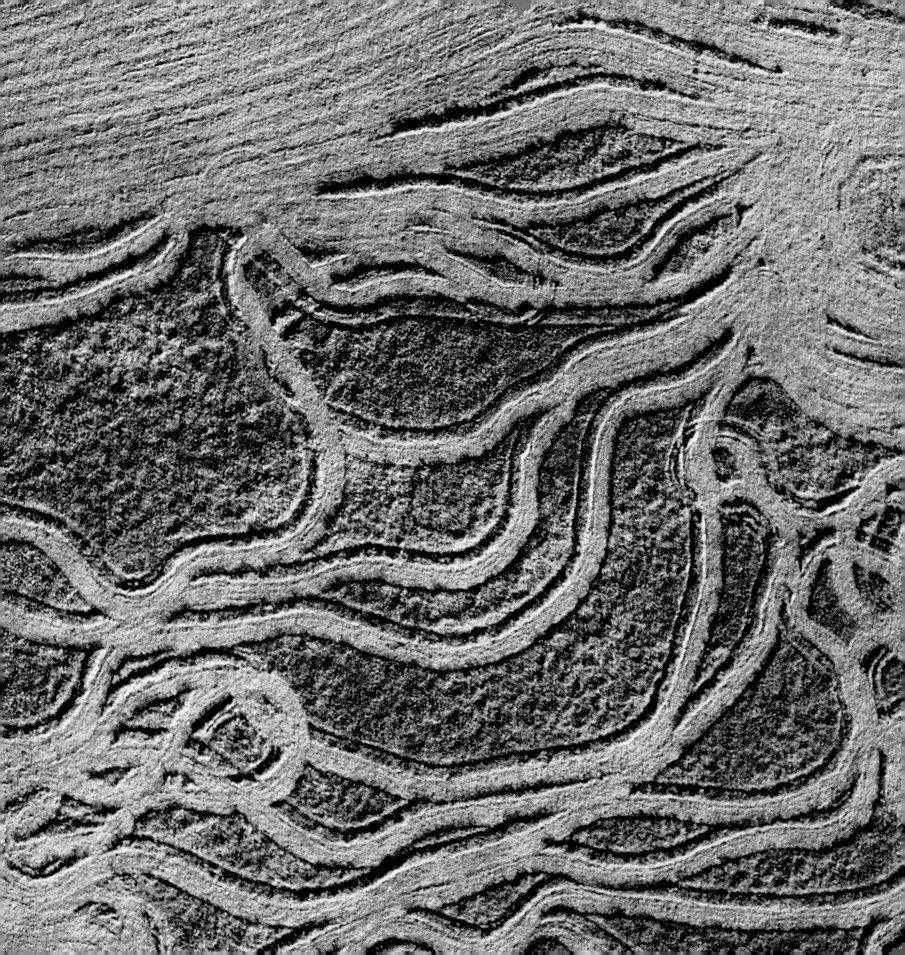

My father, a Marine Corps combat fighter pilot, flew F-4U Corsairs in the Pacific in World War II. The Corsair had a 13-foot-diameter propeller and was the fastest aircraft in the world, with over 2,000 horsepower, giving it a top speed of 446 mph. It was a difficult plane to fly, and especially tricky to land on a carrier deck. He was very proud of his skill. On my weekends with him, he would take me to the edges of airports and critique each pilot's landing techniques.

He had always promised to teach me to fly, but the years went quickly by, as they do, and it never happened. After he died, in 1995, I decided that I would have to take to the skies without his help.

After taking test flights in a dozen different ultralight aircraft, I settled on the oddly named "Six-Chuter Skye-Ryder Aerochute" as the best choice for the sort of aerial photography I had in mind. I steer this "powered parachute" with my feet, leaving my hands free to manipulate my cameras. Its 66-horsepower Rotax engine delivers a slow top speed of only 30 mph, giving me enough time over any particular landscape to frame my subjects nearly as carefully as I would do on the ground.

These photographs are a continuation of work begun in 1990, a personal exploration of the beauty I have found in the place where I was born, which first resulted in *Abandonings* (1995), color panoramic photographs of deserted houses, barns, and schools, and then *American Ruins* (1999), black-and-white panoramas of the same sort of humble structures. No longer earthbound, I have returned to color, but have started to move away from the buildings to the patterns I discovered in the surrounding fields and rivers, lakes and trees. I bring them to you in the frosty early morning, and in the golden sunset.

Maxwell MacKenzie
Washington, DC, 2007

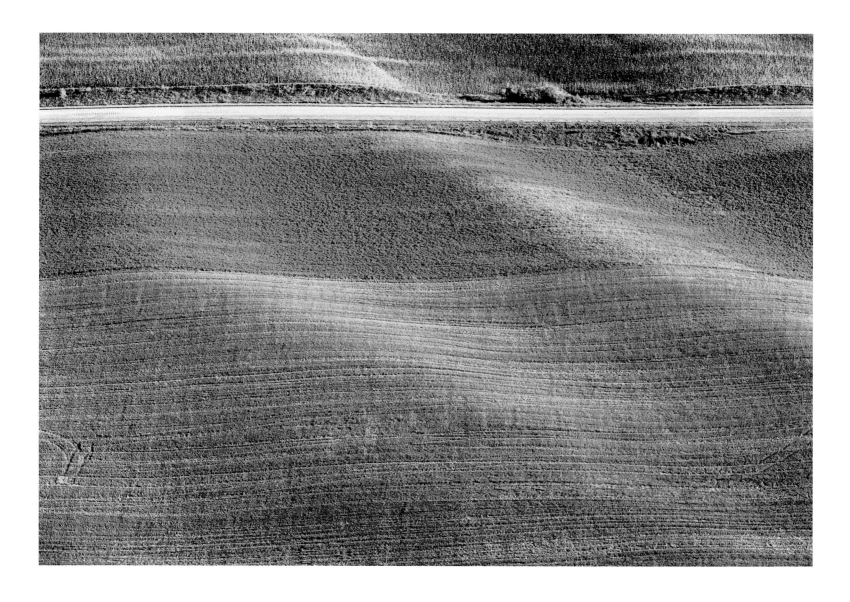

By the end of a poem, the reader should be in a different place from where he started. I would like him to be slightly disoriented at the end, like I drove him outside of town at night and dropped him off in a cornfield.

Billy Collins
New York Times

Green Snake…
a long wake of pleasure, as the leaves moved
and you faded into the pattern
of grass and shadows, and I returned
smiling and haunted, to a dark morning.

Denise Levertov
To the Snake

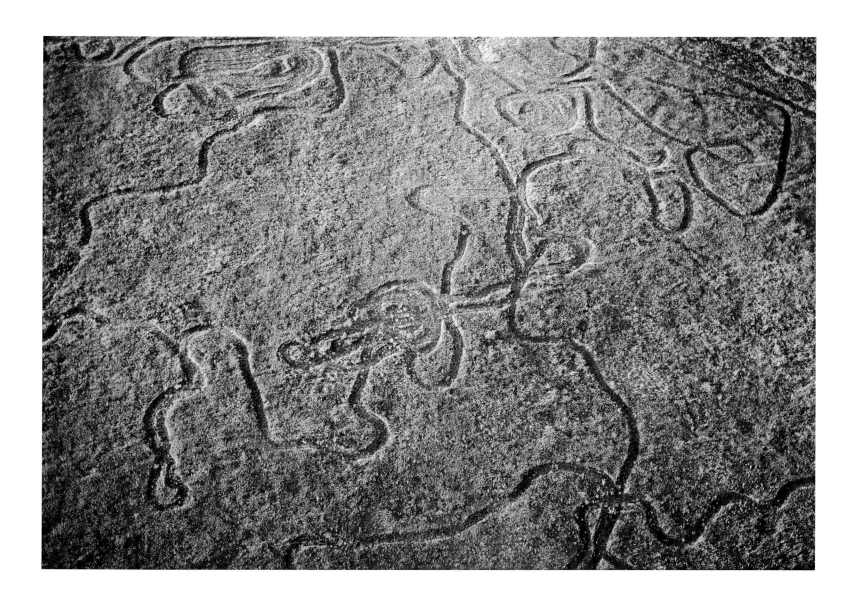

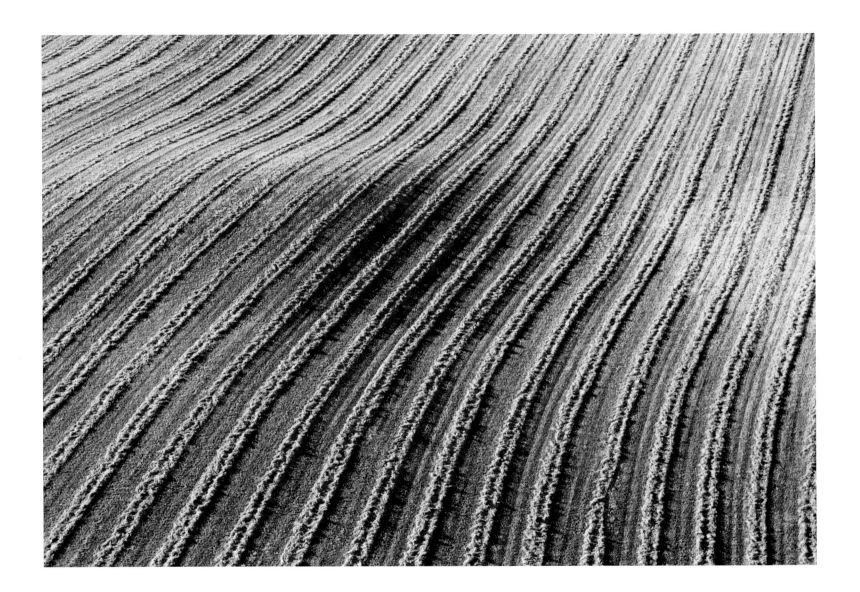

In time of silver rain

The earth

Puts forth new life again…

And over all the plain

The wonder spreads

 Of life,

 Of life,

 Of life!

Langston Hughes
In Time of Silver Rain

Beautiful you rise upon the horizon of heaven,
O living sun, you who have existed since the
 beginning of things…
The whole world is filled with your loveliness.

Akhenaten

The Hymn to the Sun

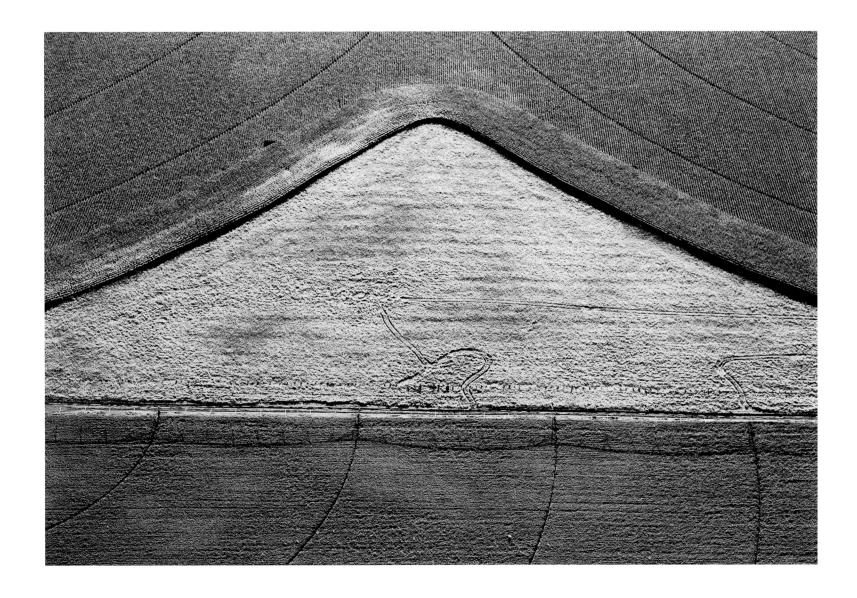

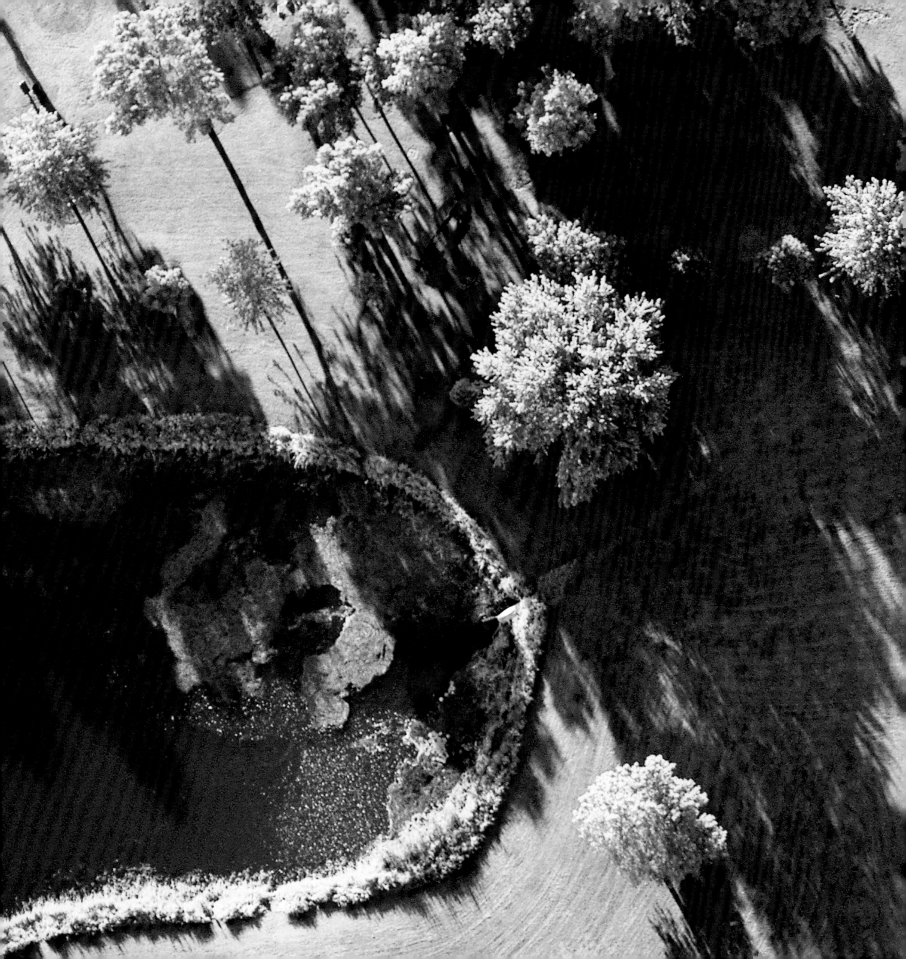

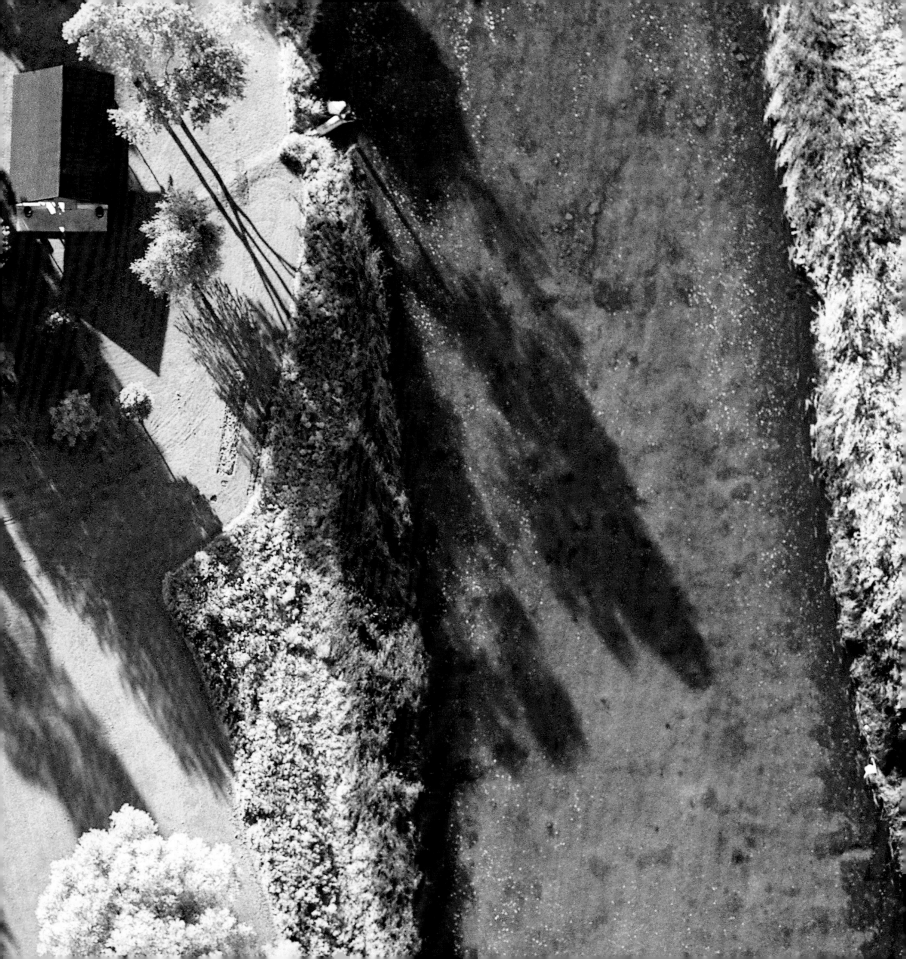

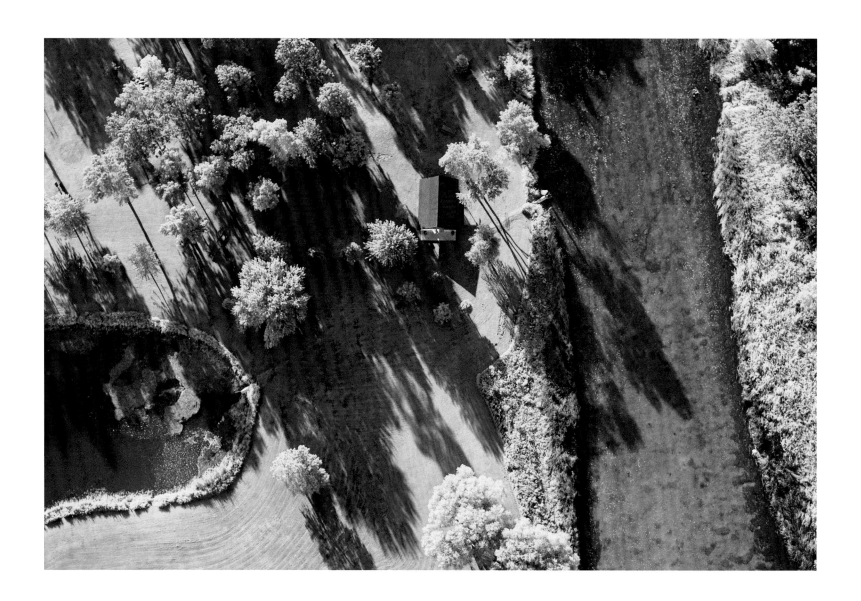

Let the light of late afternoon
shine through chinks in the barn, moving
up the bales as the sun moves down…

Let the fox go back to its sandy den.
Let the wind die down. Let the shed
go black inside. Let evening come.

Jane Kenyon
Let Evening Come

Down, down, down into the darkness of the grave
Gently they go, the beautiful, the tender, the kind;
Quietly they go, the intelligent, the witty, the brave.
I know. But I do not approve. And I am not resigned.

Edna St. Vincent Millay
Dirge without Music

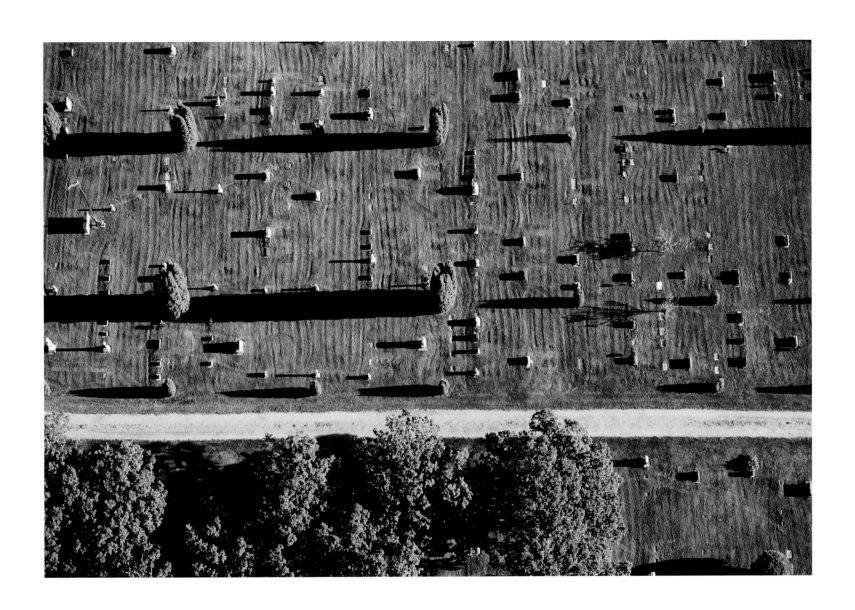

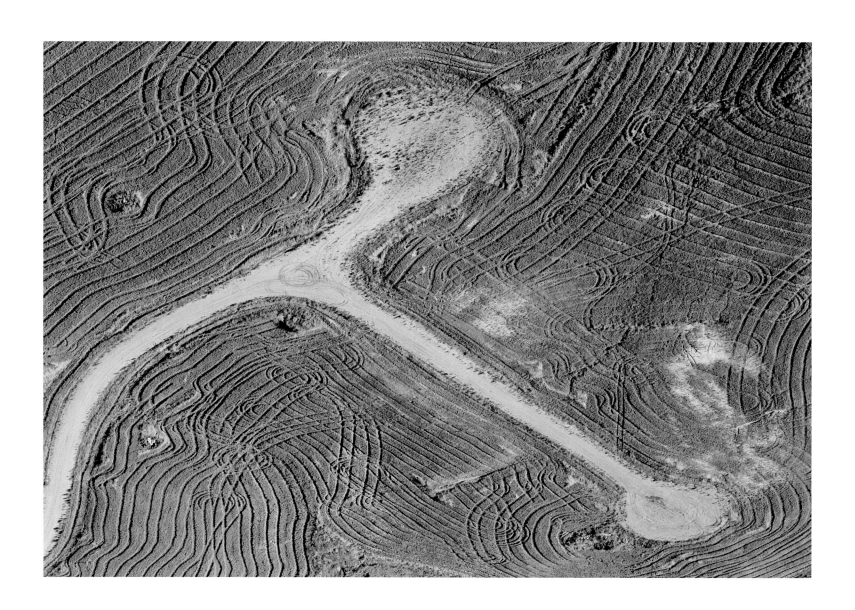

All things in this world are impermanent. They have the nature to rise and pass away. To be in harmony with this truth brings true happiness.

Buddhist chant

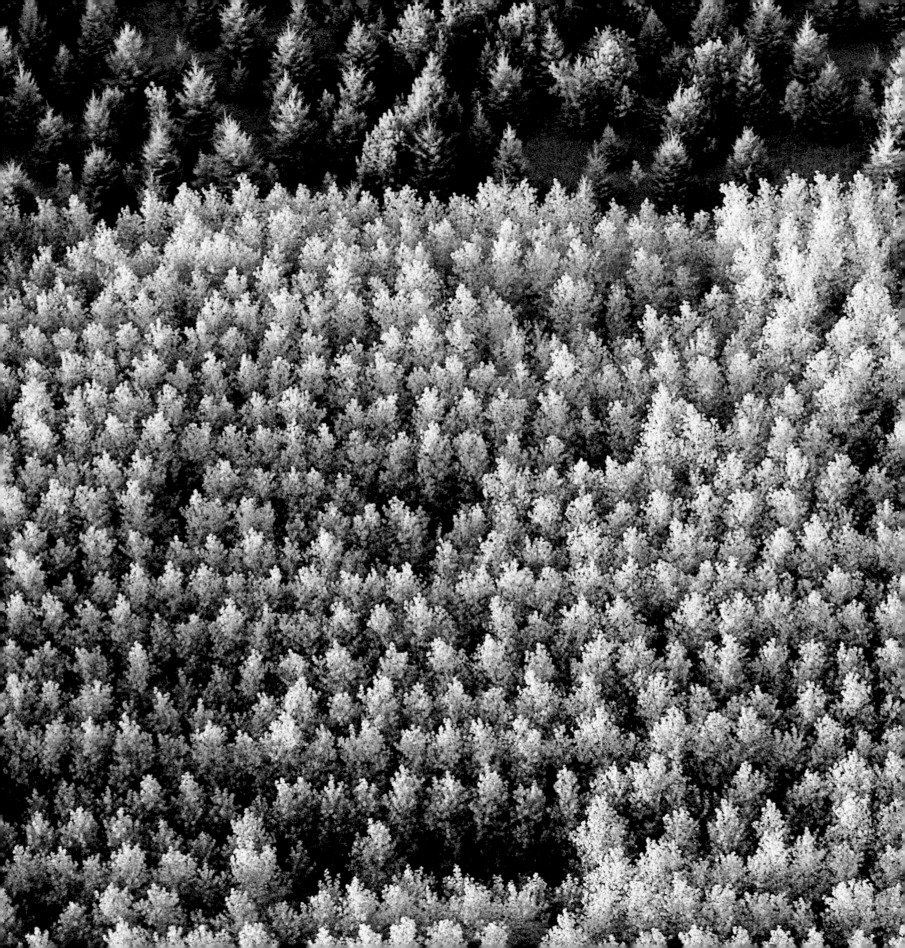

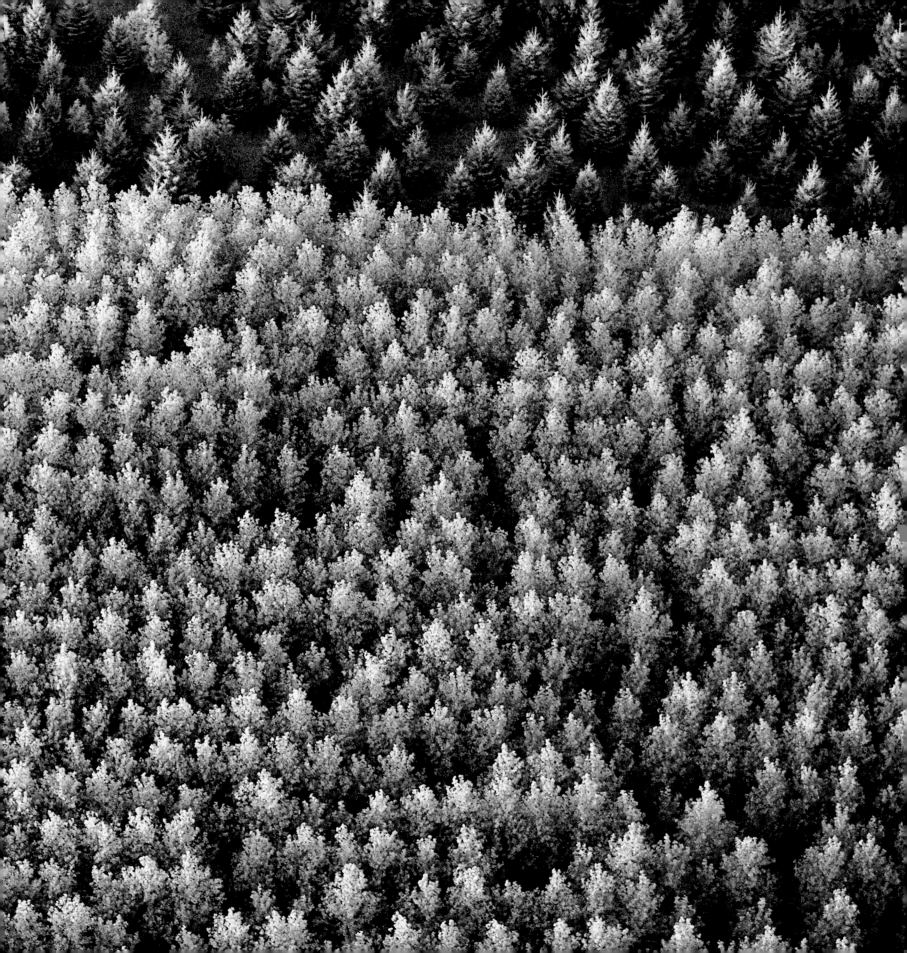

It's so still
today that a
dipping bough means
a squirrel
has gone through.

A. R. Ammons
Spruce Woods

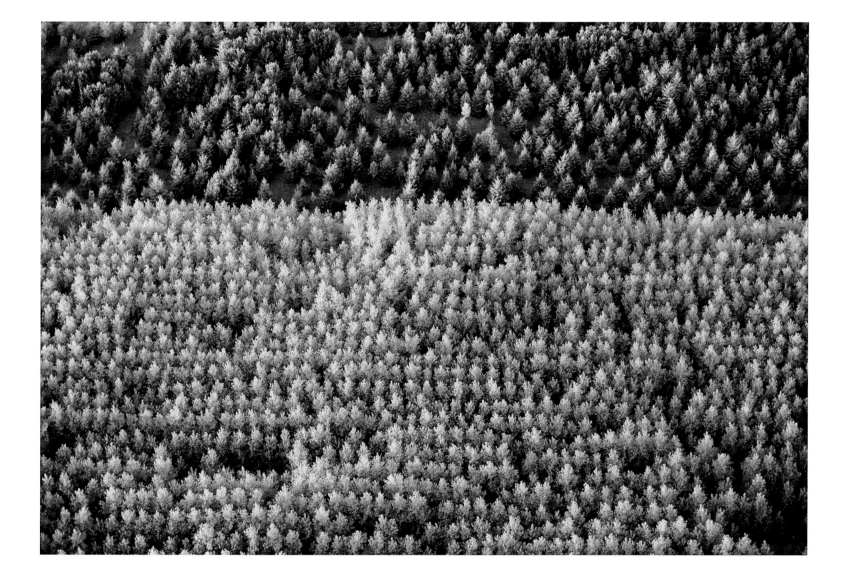

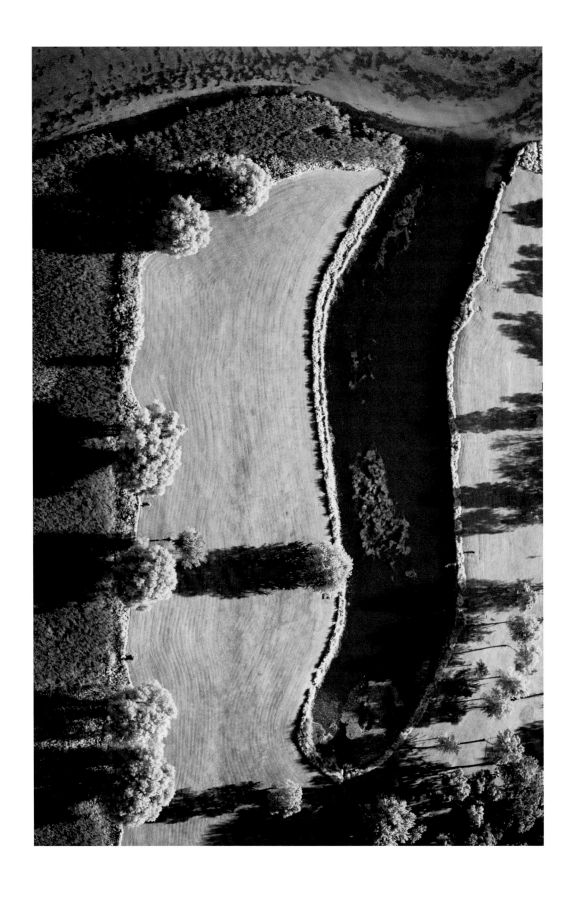

Eventually, all things merge into one,
and a river runs through it.

Norman MacLean, *A River Runs Through It*

i thank You God for most this amazing
day: for the leaping greenly spirits of trees.
…and for everything
which is natural which is infinite which is yes…

(now the ears of my ears awake and
now the eyes of my eyes are opened)

e. e. cummings
i thank You God for most this amazing

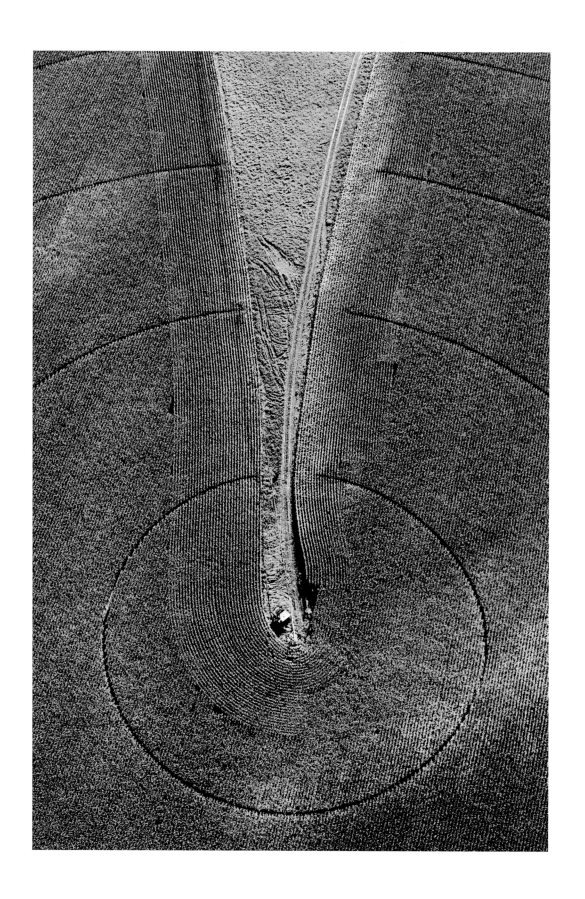

The butterfly counts not days
but moments,
and has time
enough.

Rabindranath Tagore
Fireflies

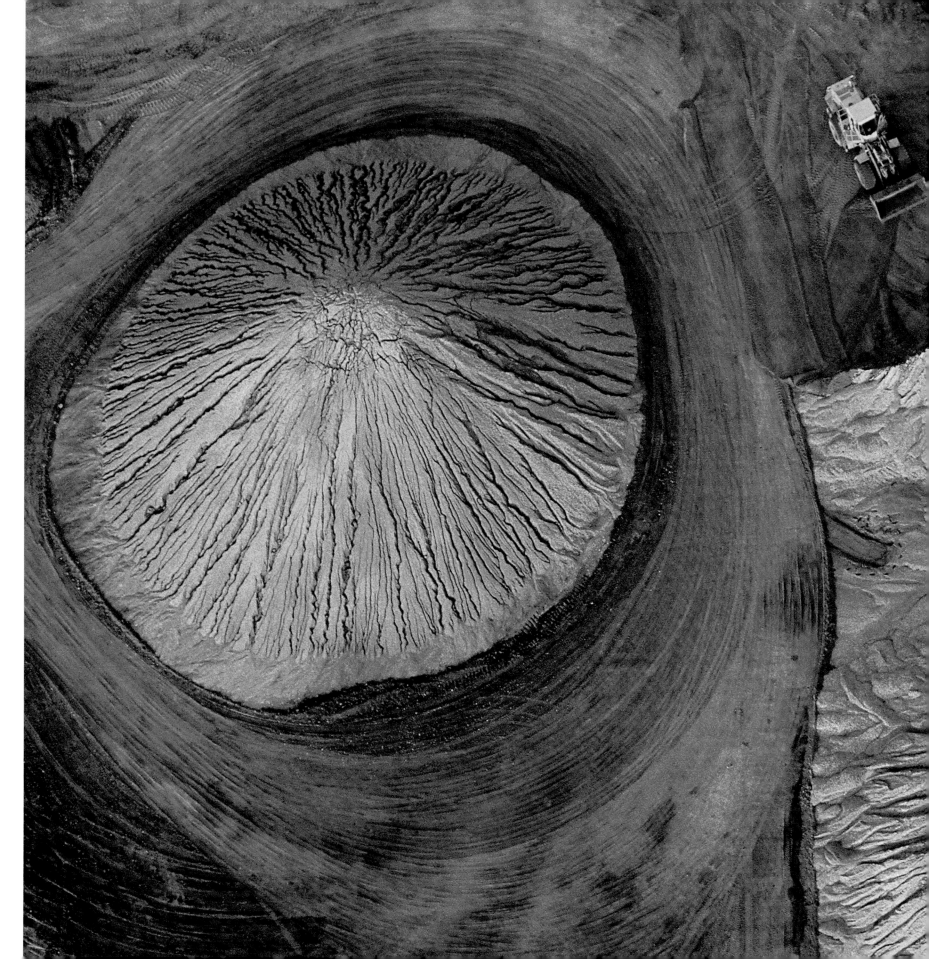

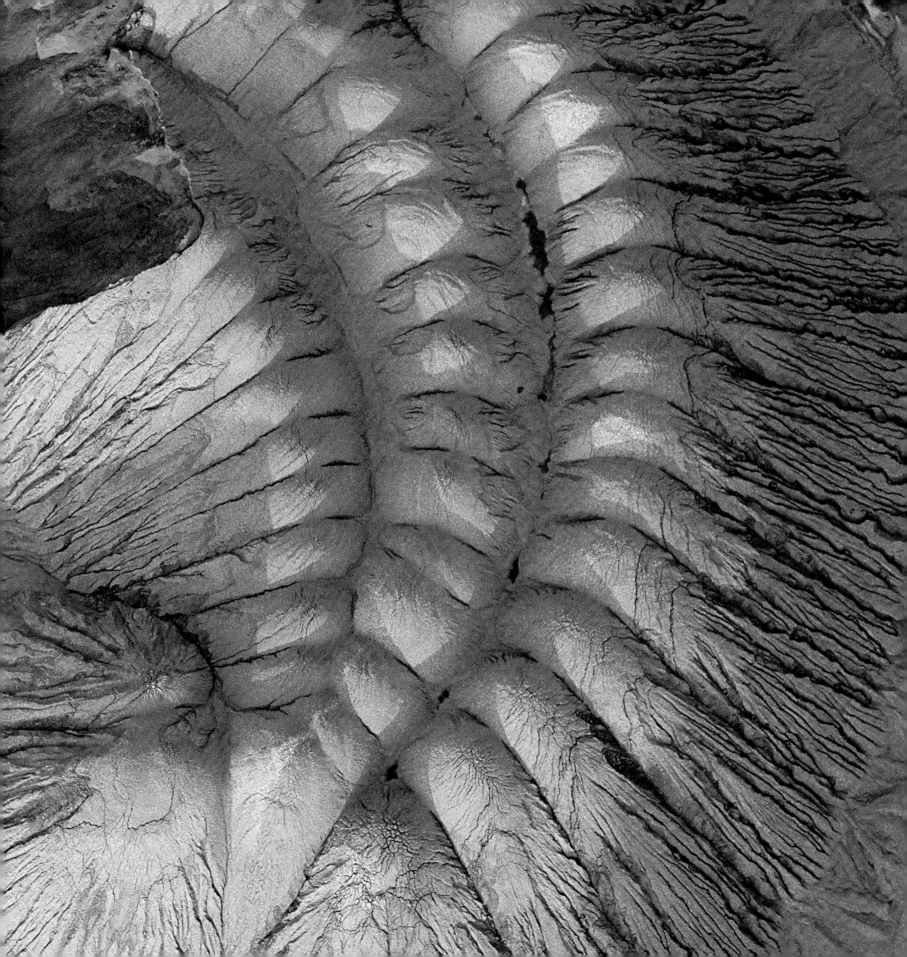

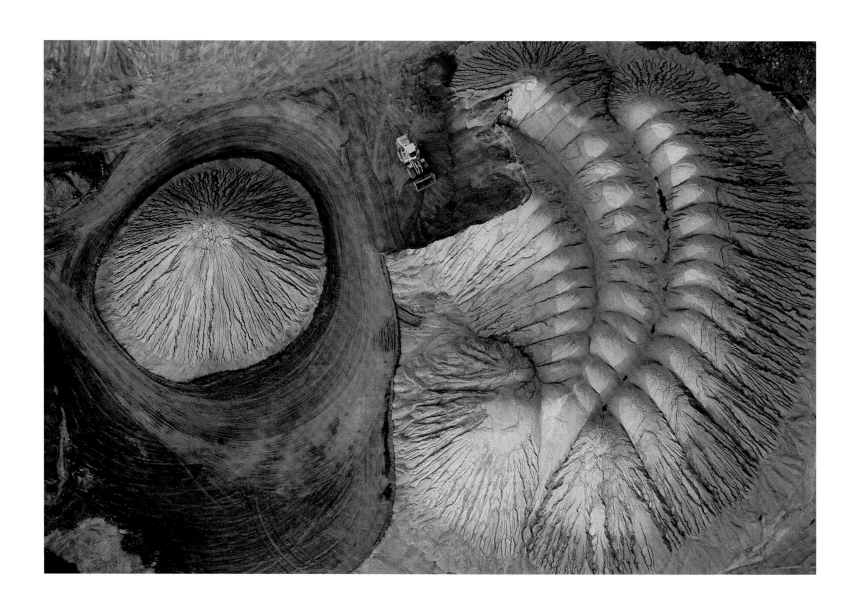

My eyes already touch the sunny hill
going far ahead of the road I have begun.
So we are grasped by what we cannot grasp;
It has inner light, even from a distance—
and changes us, even if we do not reach it.

Rainer Maria Rilke

A Walk

I asked the Scotchman what was his objection to Indiana: "Objection," he replied with a strong Highland accent; "objection, did ye say? There is no objection but to its over-fruitfulness. The soil is so rich, the climate so delicious, that the farmer has no adequate inducement to work. The earth produces its fruits too readily. The original curse presses too lightly… here in Indiana, Illinois, and away to the West, as far as you can go, man gains his bread too easily to remain virtuous."

Charles Mackay
Life and Liberty in America

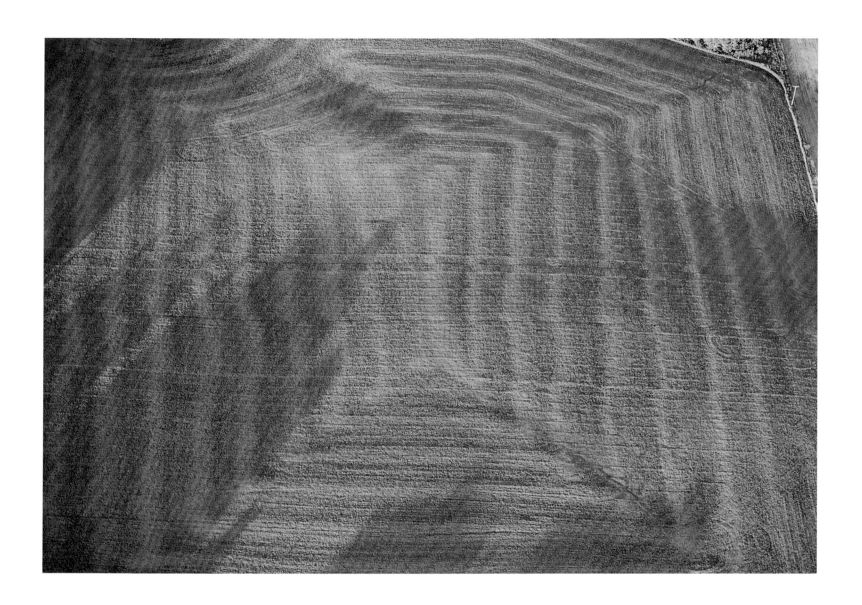

The buffaloes are gone.

And those who saw the buffaloes are gone.

Those who saw the buffaloes by thousands and how they
 pawed the prairie sod into dust with their great hoofs,
 their great heads down pawing on in a great pageant
 of dusk,

Those who saw the buffaloes are gone.

And the buffaloes are gone.

Carl Sandburg
Buffalo Dusk

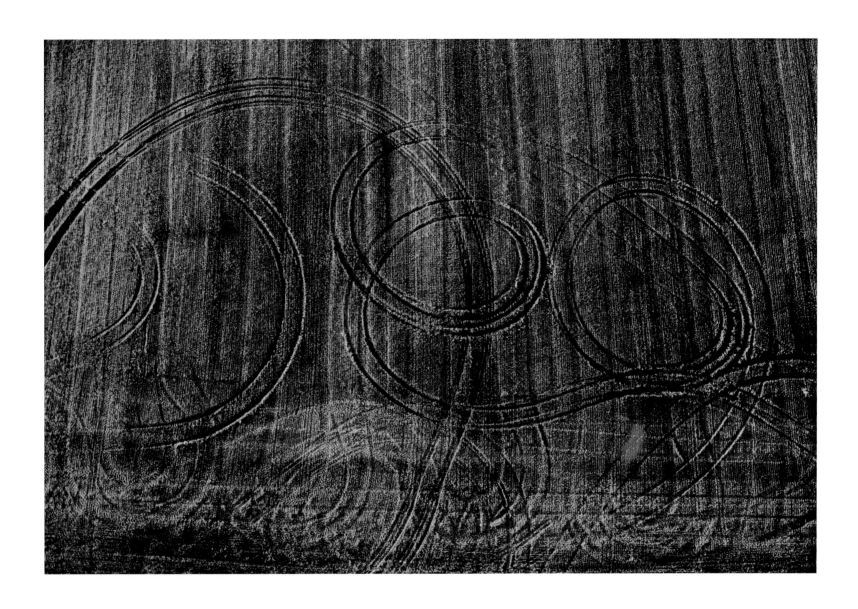

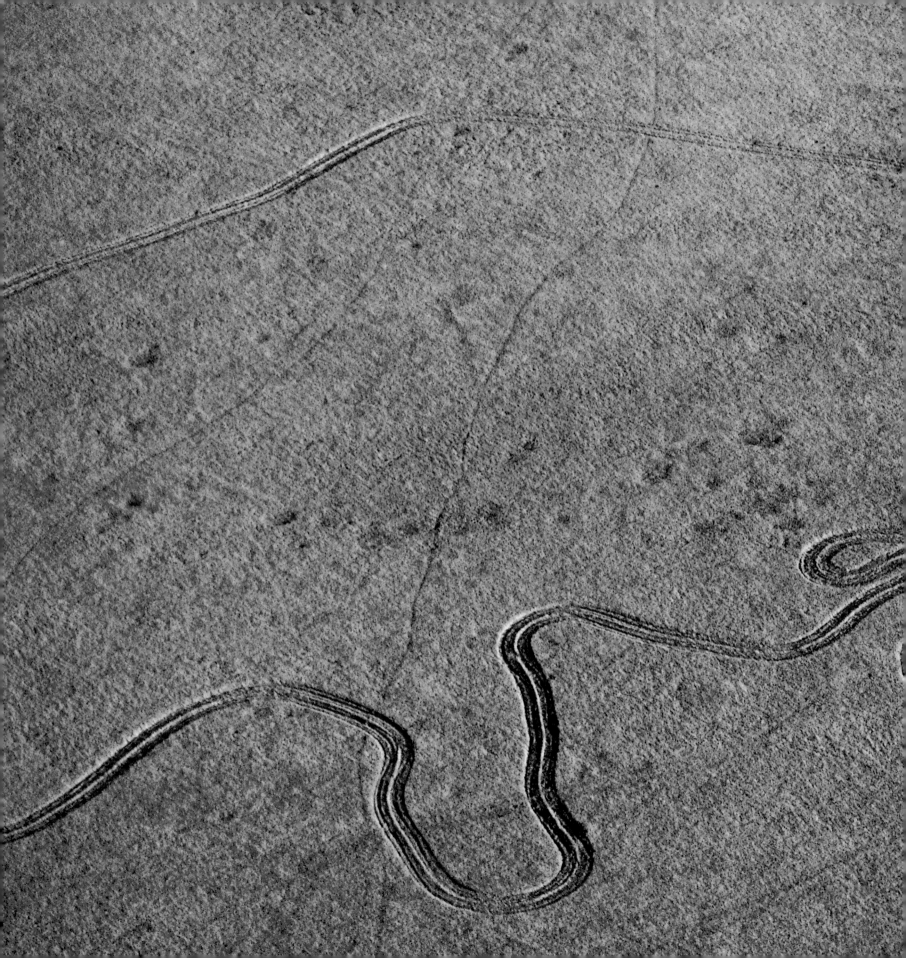

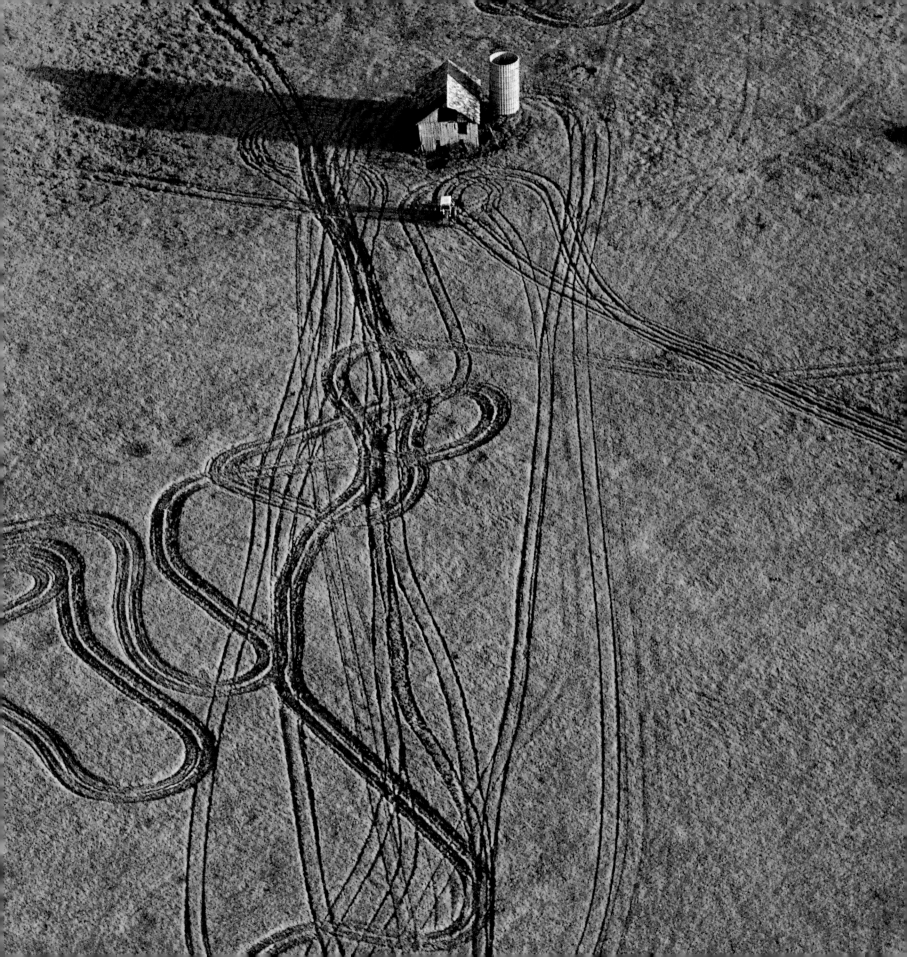

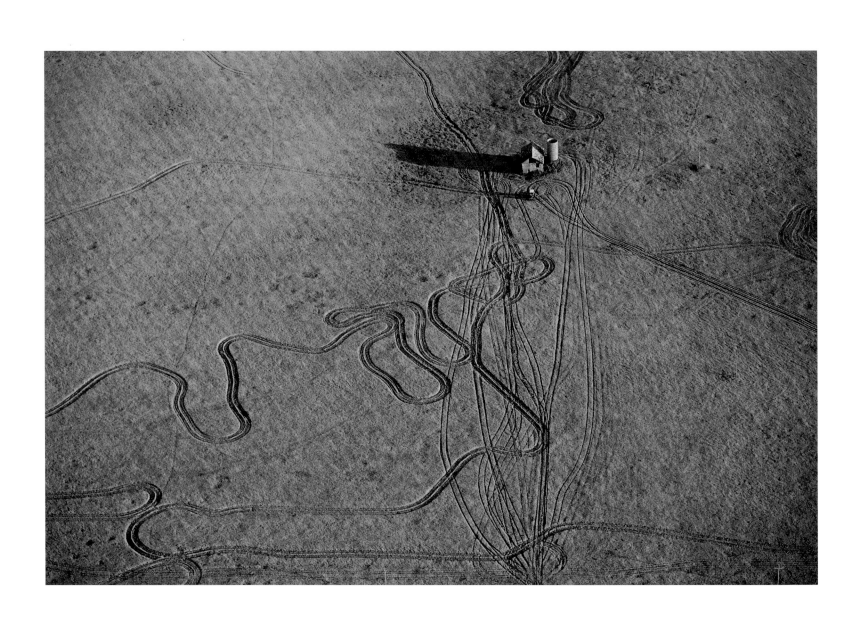

And as I was green and carefree, famous among the barns
About the happy yard and singing as the farm was home,
 In the sun that is young once only,
 Time let me play and be
 Golden in the mercy of his means.

Dylan Thomas
 Fern Hill

What is life? It is the flash of a firefly in the night.
It is the breath of a buffalo in the wintertime.
It is the little shadow which runs across the grass
 and loses itself in the sunset.

Chief Crowfoot
Blackfoot Nation

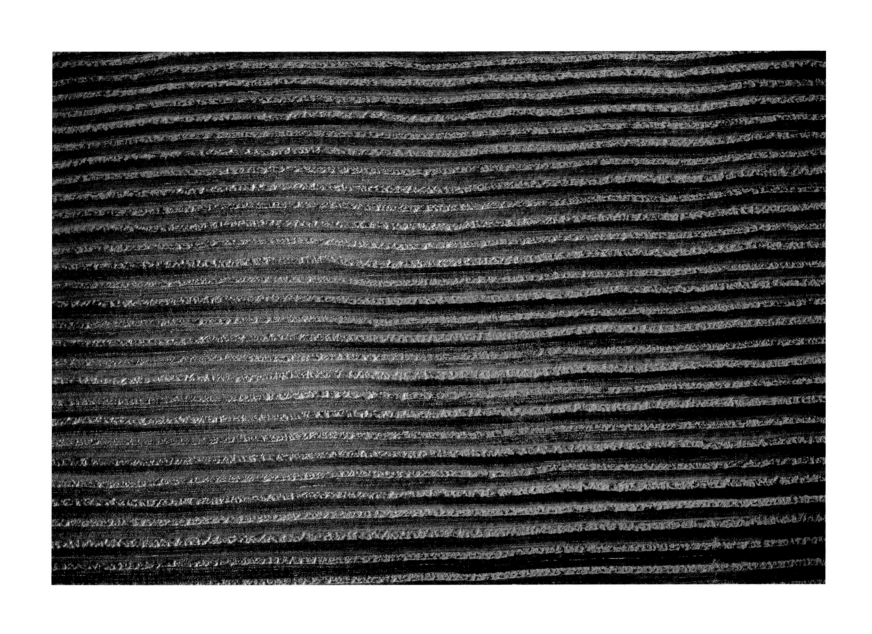

Had I the heavens' embroidered cloths,

Enwrought with golden and silver light…

I would spread the cloths under your feet.

William Butler Yeats

He Wishes for the Cloths of Heaven

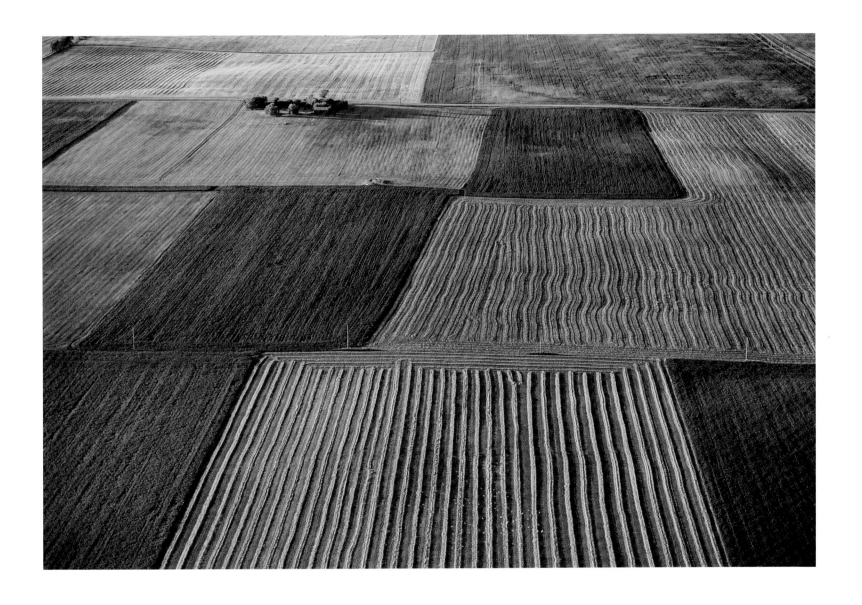

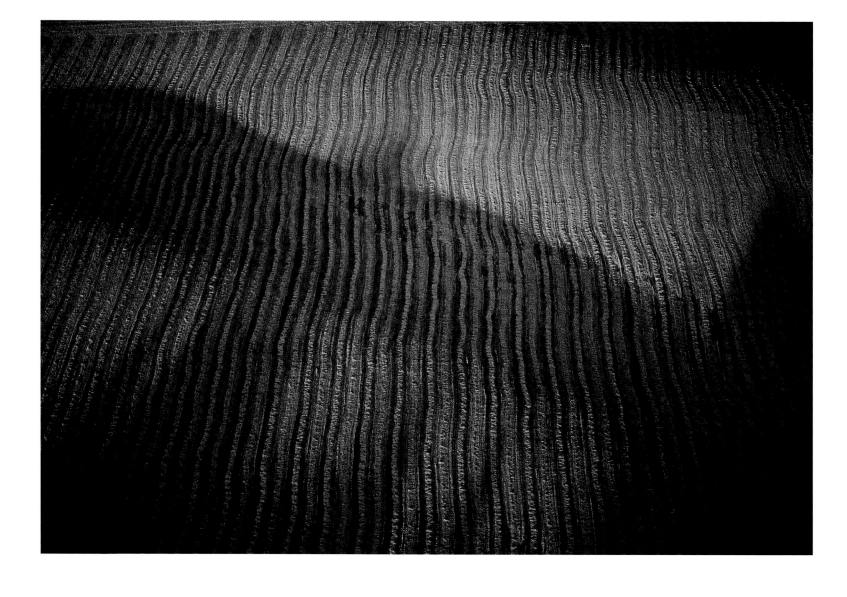

Would that life were like the shadow cast by a wall or a tree, but it is like the shadow of a bird in flight.

The Talmud

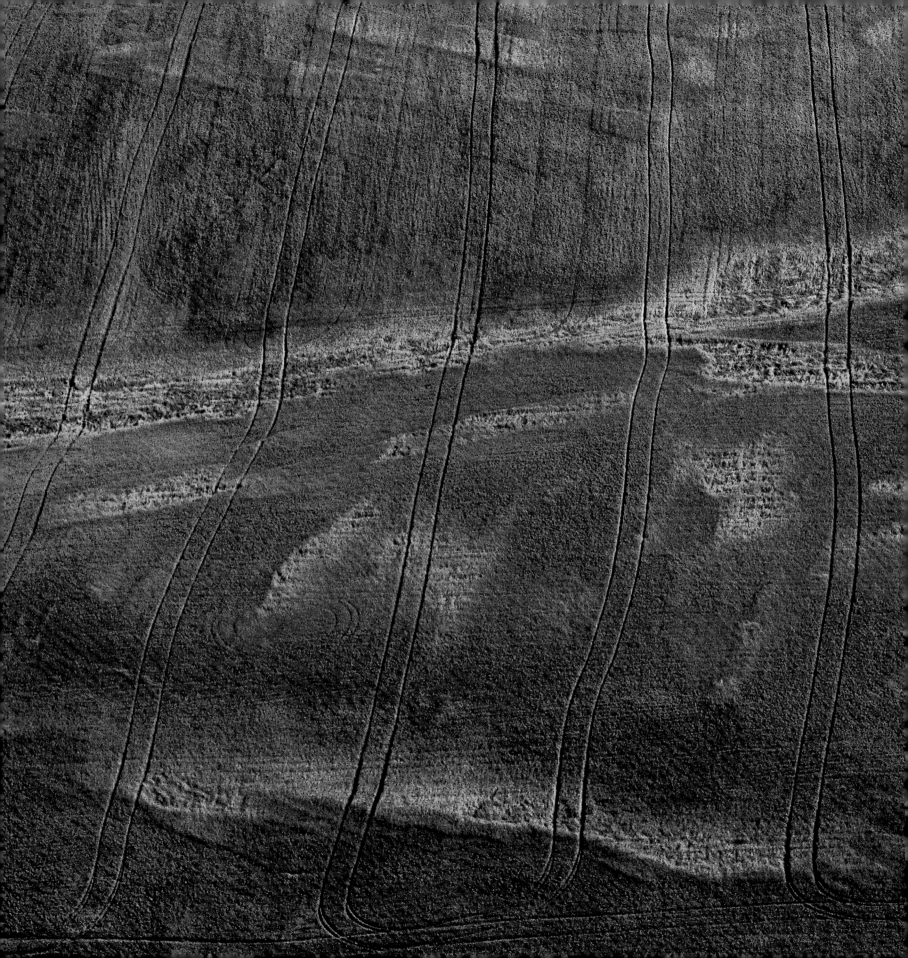

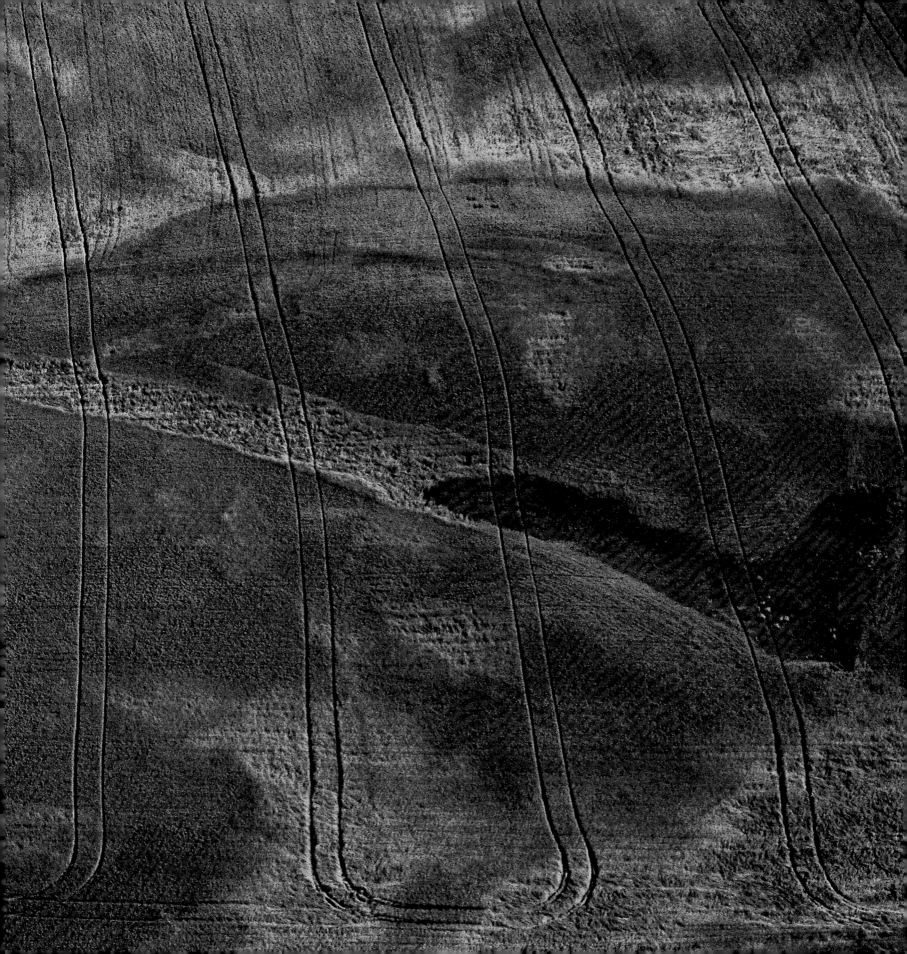

The poetry of earth is ceasing never ...

John Keats

On the Grasshopper and the Cricket

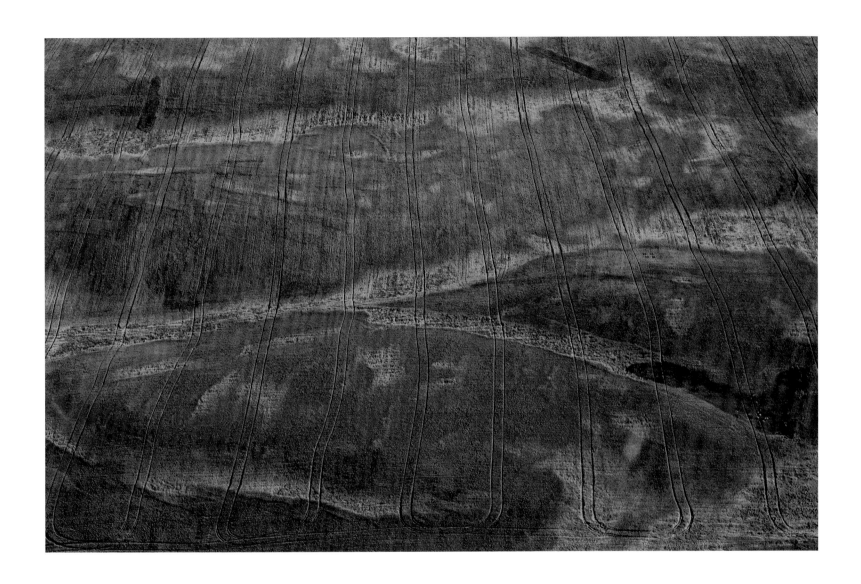

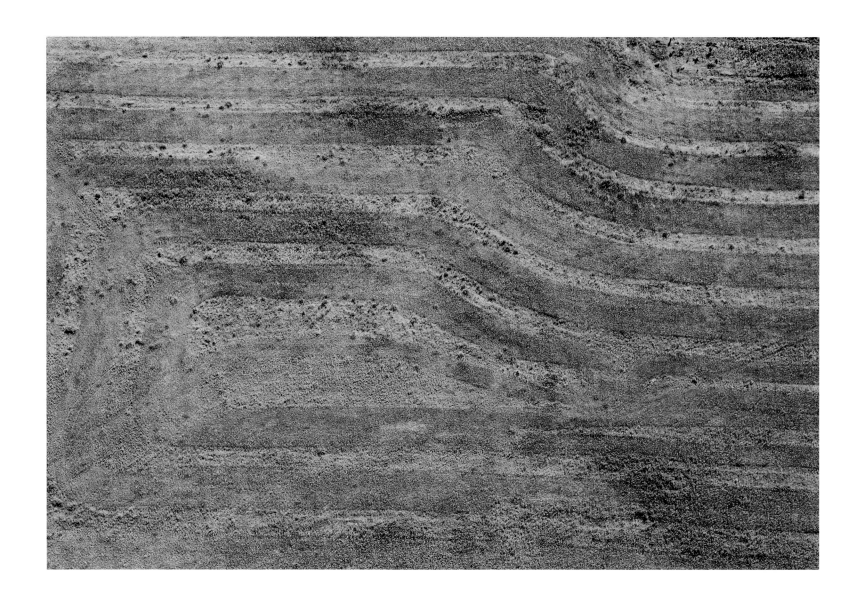

Once again the fields we mow

And gather in the aftermath.

Not the sweet, new grass with flowers

In this harvesting of ours;

Not the upland clover bloom;

But the rowen mixed with weeds,

Tangled tufts from marsh and meads,

Where the poppy drops its seeds

In the silence and the gloom.

Henry Wadsworth Longfellow
Aftermath

"I'm sixty-eight," he said,
"I first bucked hay when I was seventeen.
I thought, that day I started,
I sure would hate to do this all my life.
And dammit, that's just what
I've gone and done."

Gary Snyder
Hay for the Horses

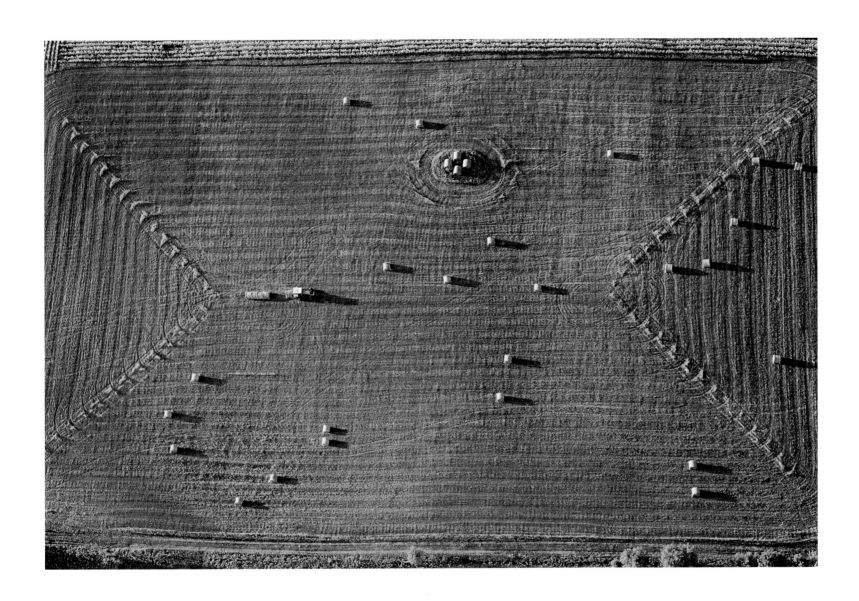

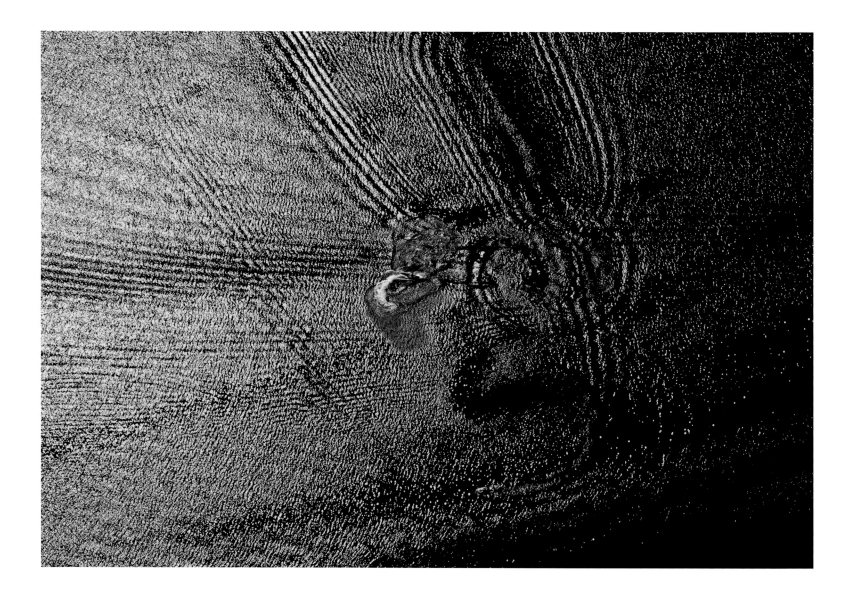

The grey sea and the long black land;

And the yellow half-moon large and low;

And the startled little waves that leap

In fiery ringlets from their sleep,

As I gain the cove with pushing prow,

And quench its speed i' the slushy sand.

Robert Browning
Meeting at Night

To make a prairie it takes a clover
 and one bee,
One clover, and a bee,
And revery.
The revery alone will do,
If bees are few.

Emily Dickinson
To Make a Prairie

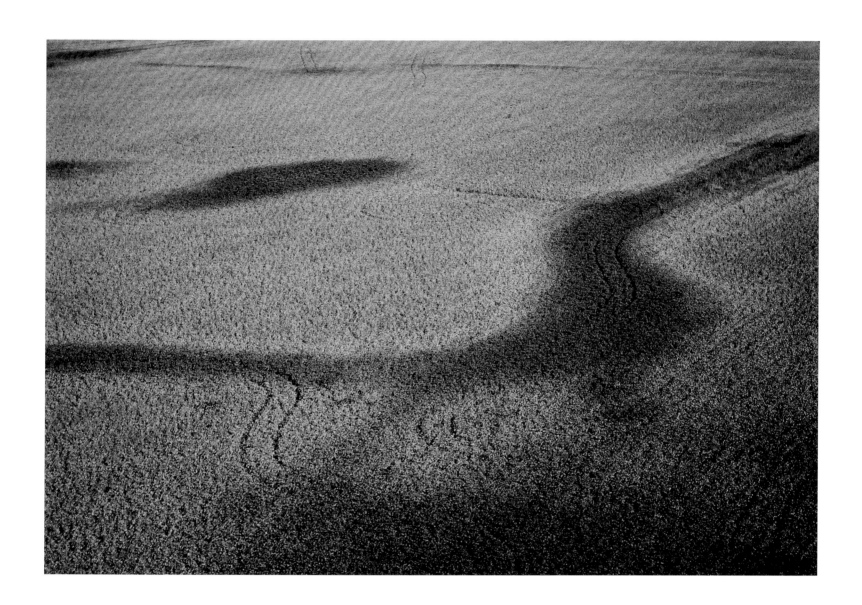

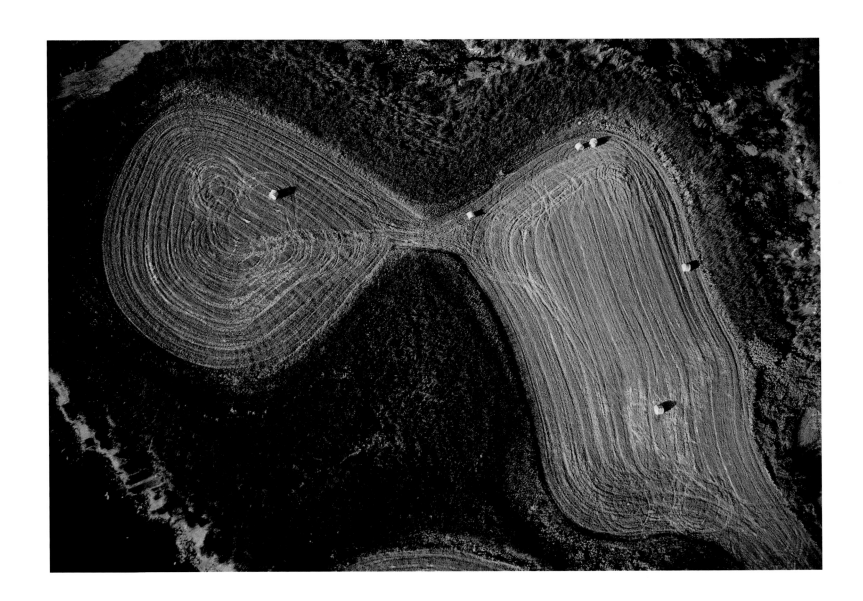

You will find poetry nowhere unless you bring some of it
with you.

Joseph Joubert
The Notebooks of Joseph Joubert

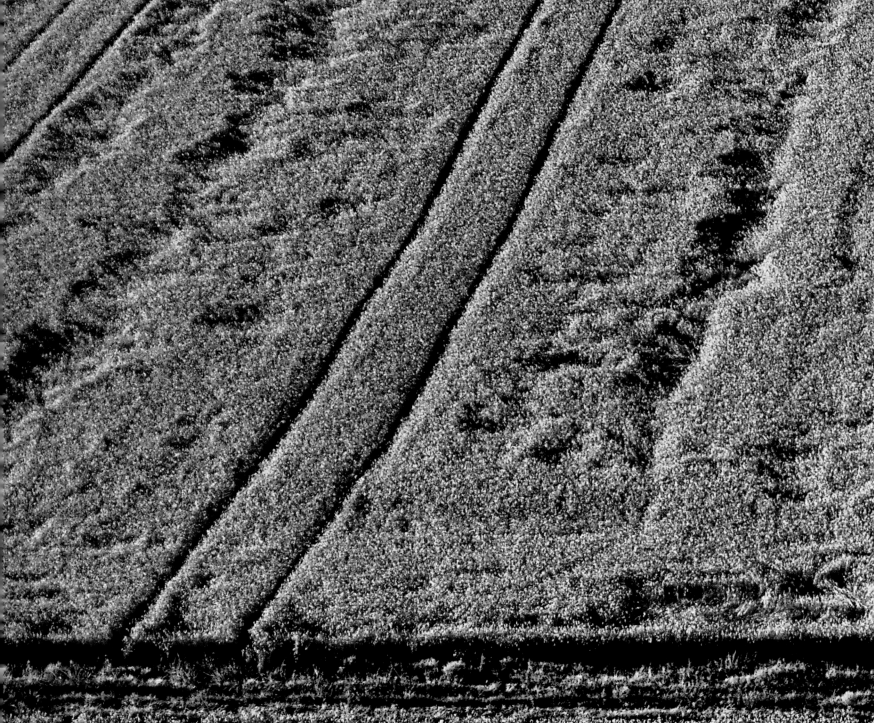

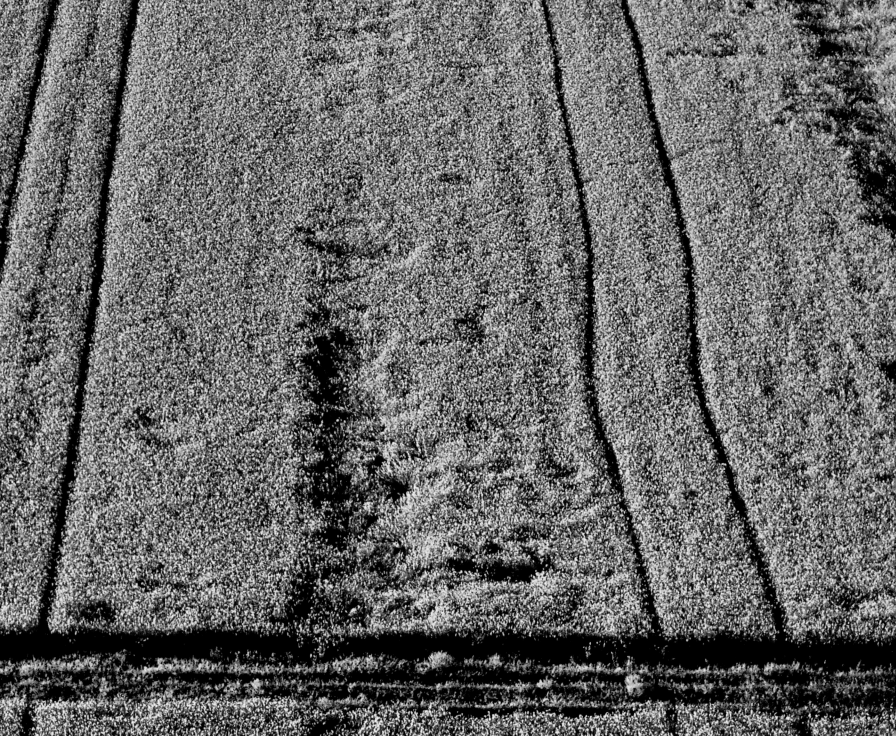

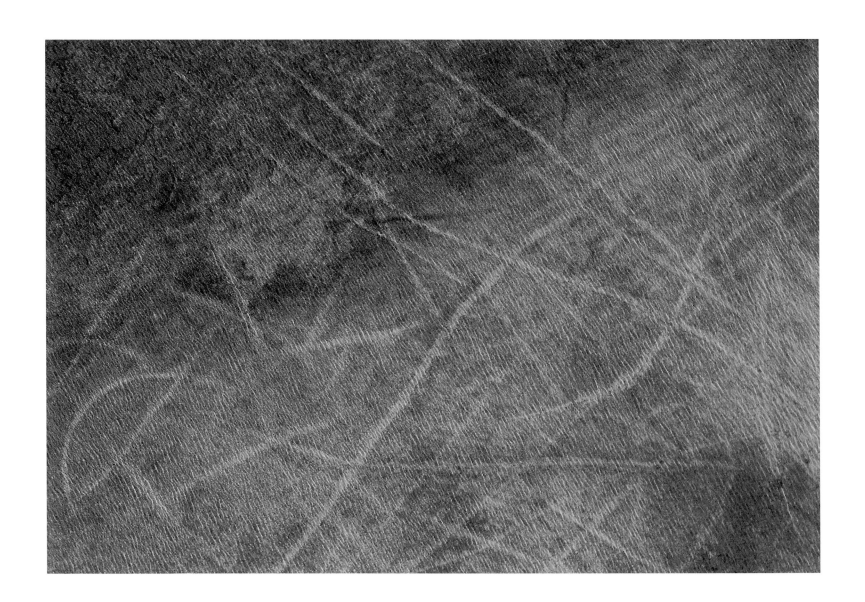

Life flows to death as rivers to the sea,
And life is fresh and death is salt to me.

<div align="right">

J. V. Cunningham

Doctor Drink

</div>

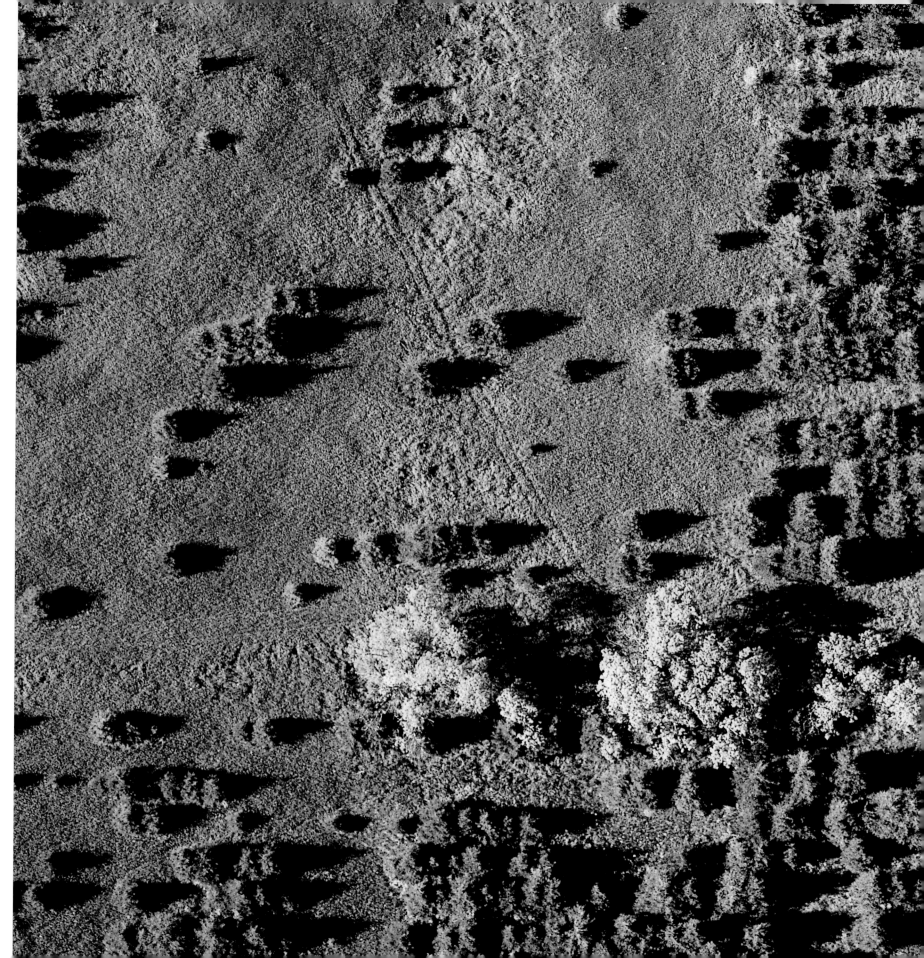

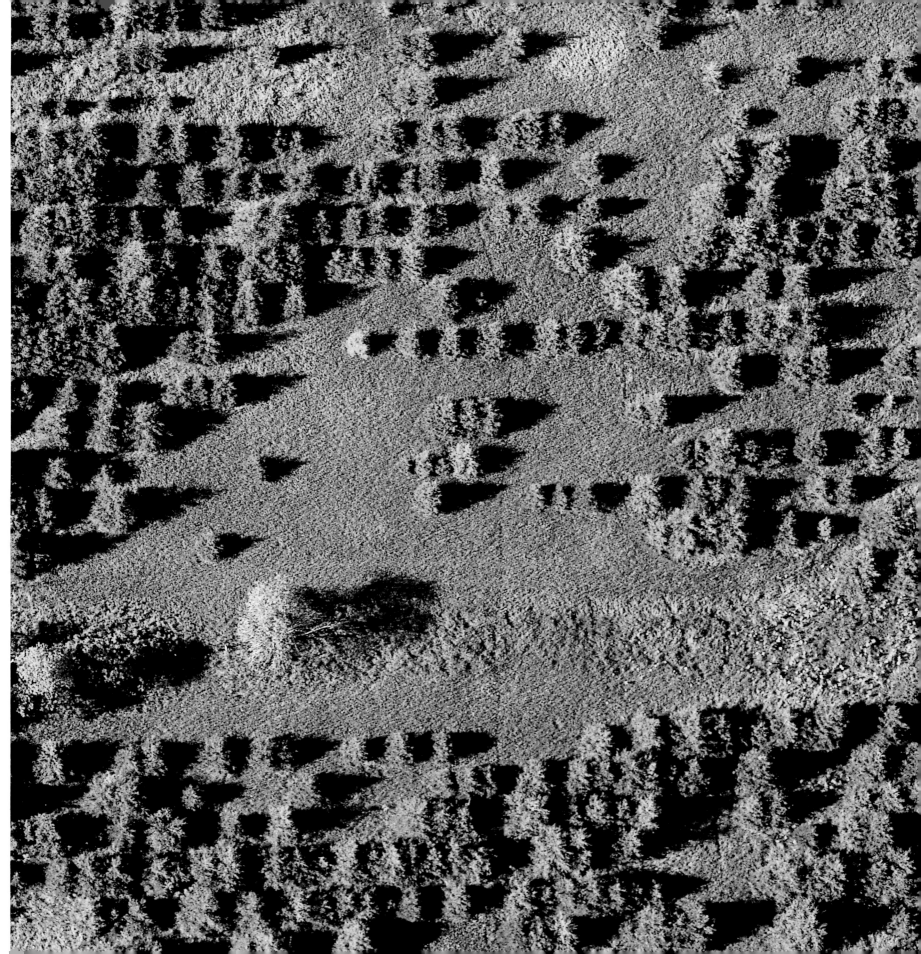

Acknowledgments

I owe a great debt to the many people who assisted me in this project, beginning foremost with Rebecca Cross, my wife of twenty-five years, without whose sustained strong support this work would never have been completed.

When, in 1996, I suggested the idea of purchasing a new type of rudimentary flying machine—known as a powered parachute—for the purpose of making aerial photographs, she was, to put it mildly, against the idea. But after a year or two, a hundred flights, no injuries, and the beginnings of some good images, she came around, and has tolerated with good humor the unconventional and weather-dependent life, which the pursuit of this idea has required of us.

Over the past ten years, Becca has contributed to every aspect of the work, from image editing to quote research, even helping me drive the PPC trailer back and forth across the country numerous times. She has endured being woken up by countless pre-dawn motor warm-ups, and suffered seeing every spare dollar disappear into cameras, aircraft, hangars, airstrips, mowers, gas, and of course, a great deal of film.

I also want to thank Terry Mansell, of Eagle View Flightline, Clearwater, Minnesota, who gently taught me to fly low and slow, and Eason and Diana Cross, who generously allowed me to turn their once-peaceful Nanzatico Lane farm on the Rappahannock into my own private airport, and encouraged me to explore from above the wonders of King George County, Virginia.

We are so fortunate out in Otter Tail County, Minnesota, to have as neighbors the Murphys: Tom, Betty, Matthew, Mark, Natalie, Patrick, and Ryan, who have shown us great kindness and limitless patience with very early and very late flights, and who have watched over our little red schoolhouse when we are away.

Carol Boyd, John McMahon, and many others at Dodge Color, Silver Spring, Maryland, used their considerable skills to make luminous prints from my 35mm slides, which Chris Addison, Sylvia Ripley, Anne Levine, and Romy Silverstein exhibited in 2004, in their beautiful gallery, Addison/Ripley Fine Art, in Georgetown.

Gail Dickersin Spilsbury saw that show, imagined a book, brought in her talented colleague from the National Gallery of Art, Wendy Schleicher, and together with my editor, Ruth Saxe, they made this volume happen.